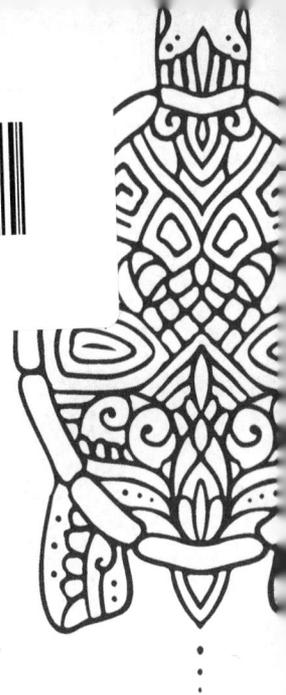

This book belongs to

Coloring book for Adults

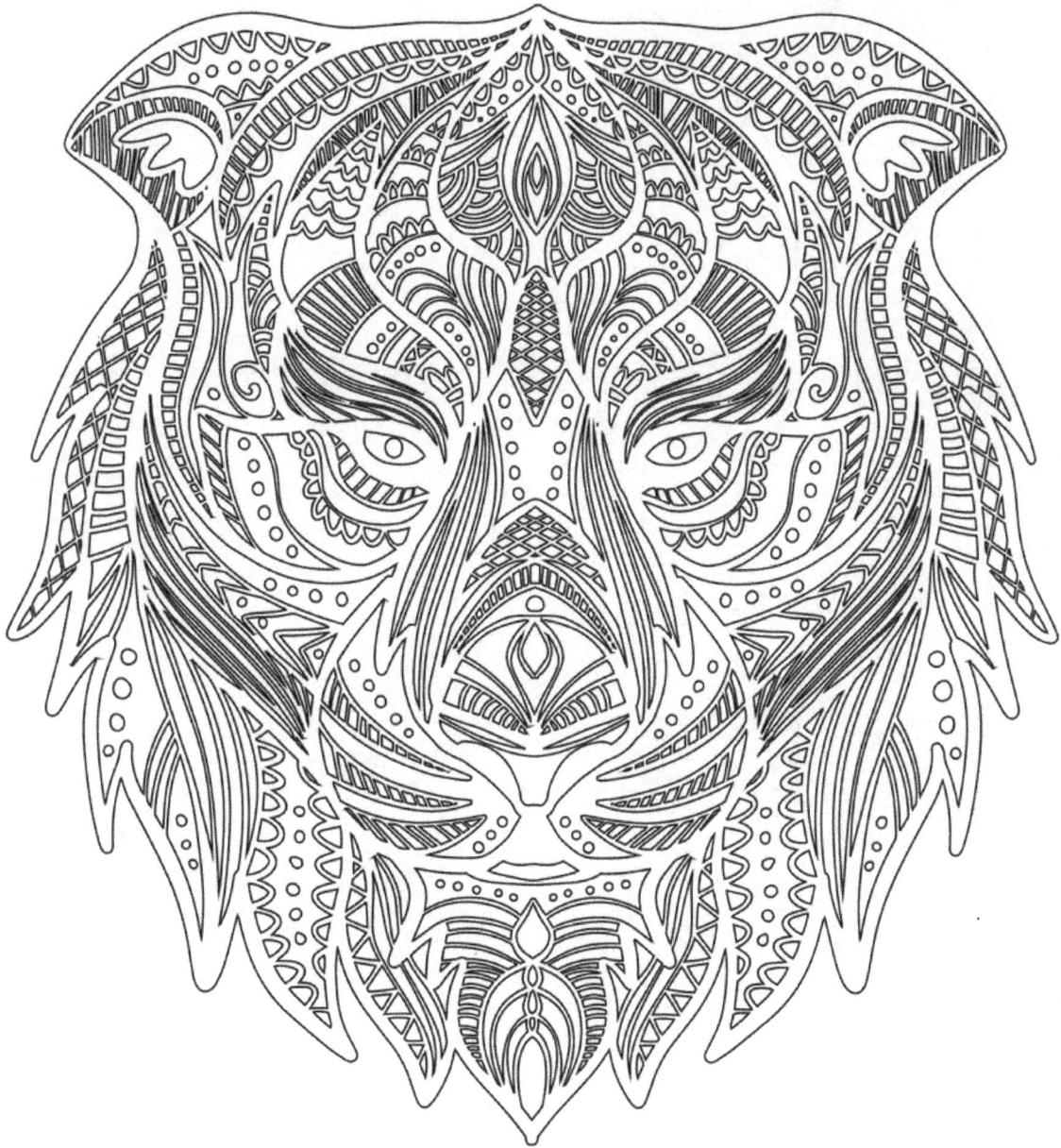

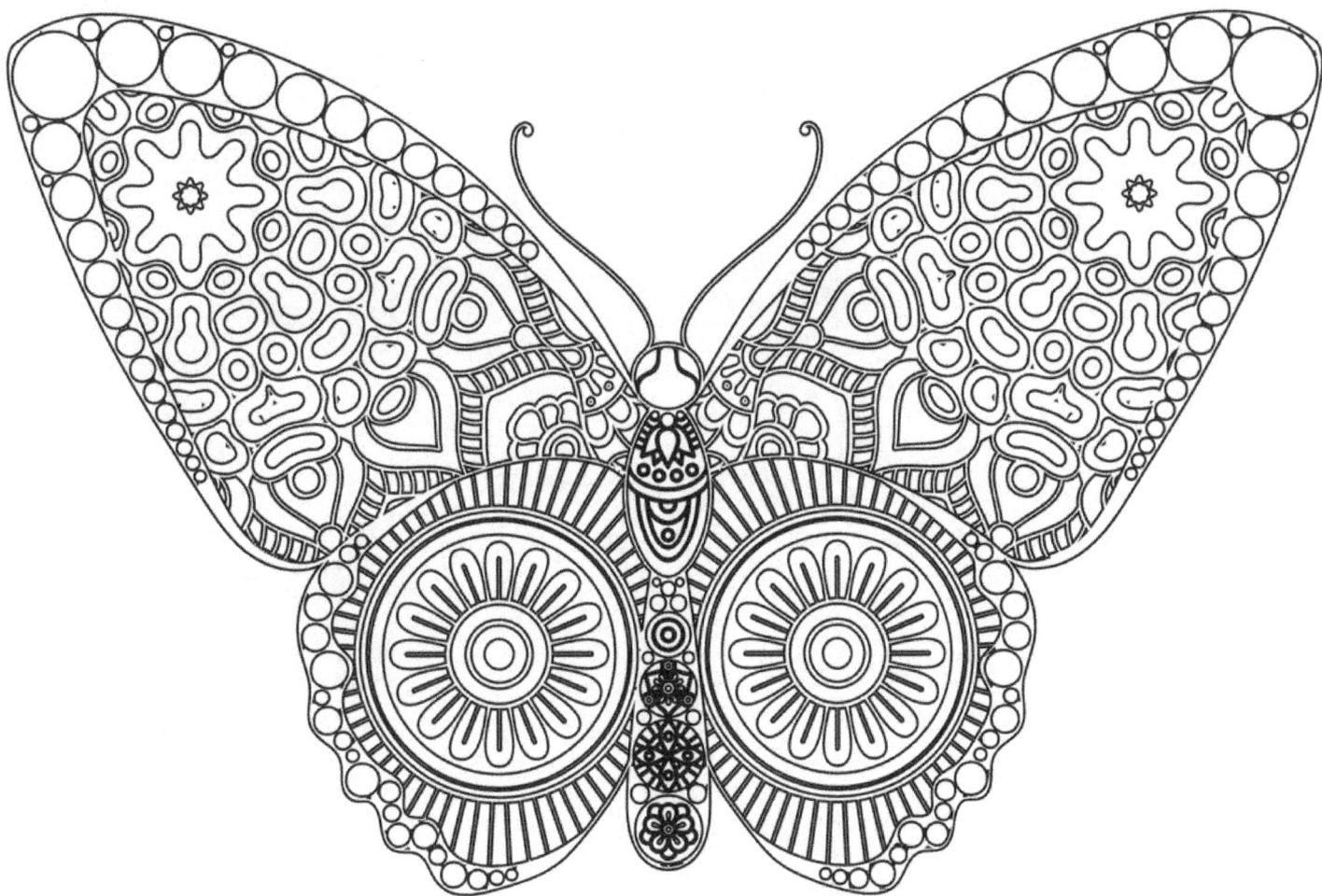

3

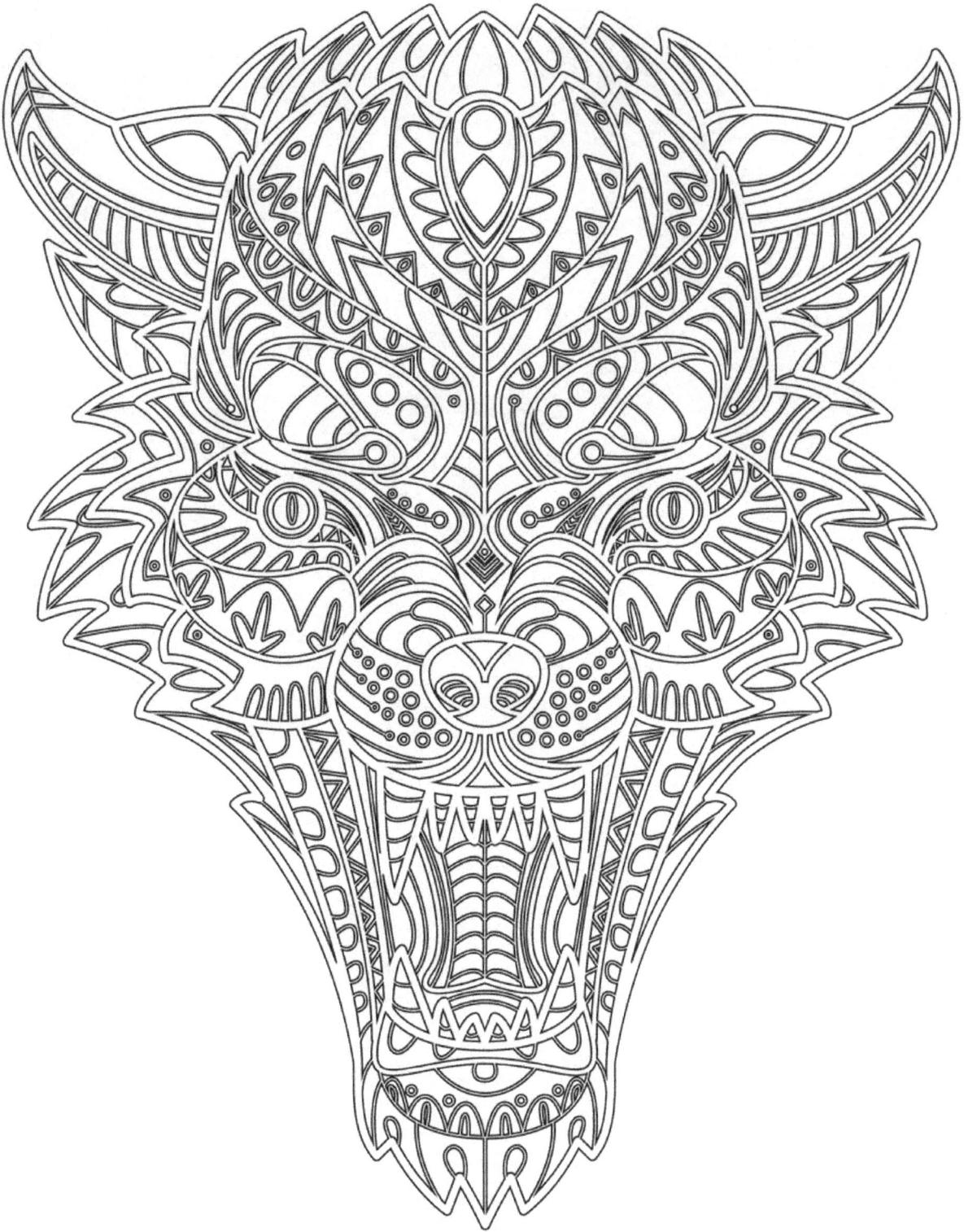

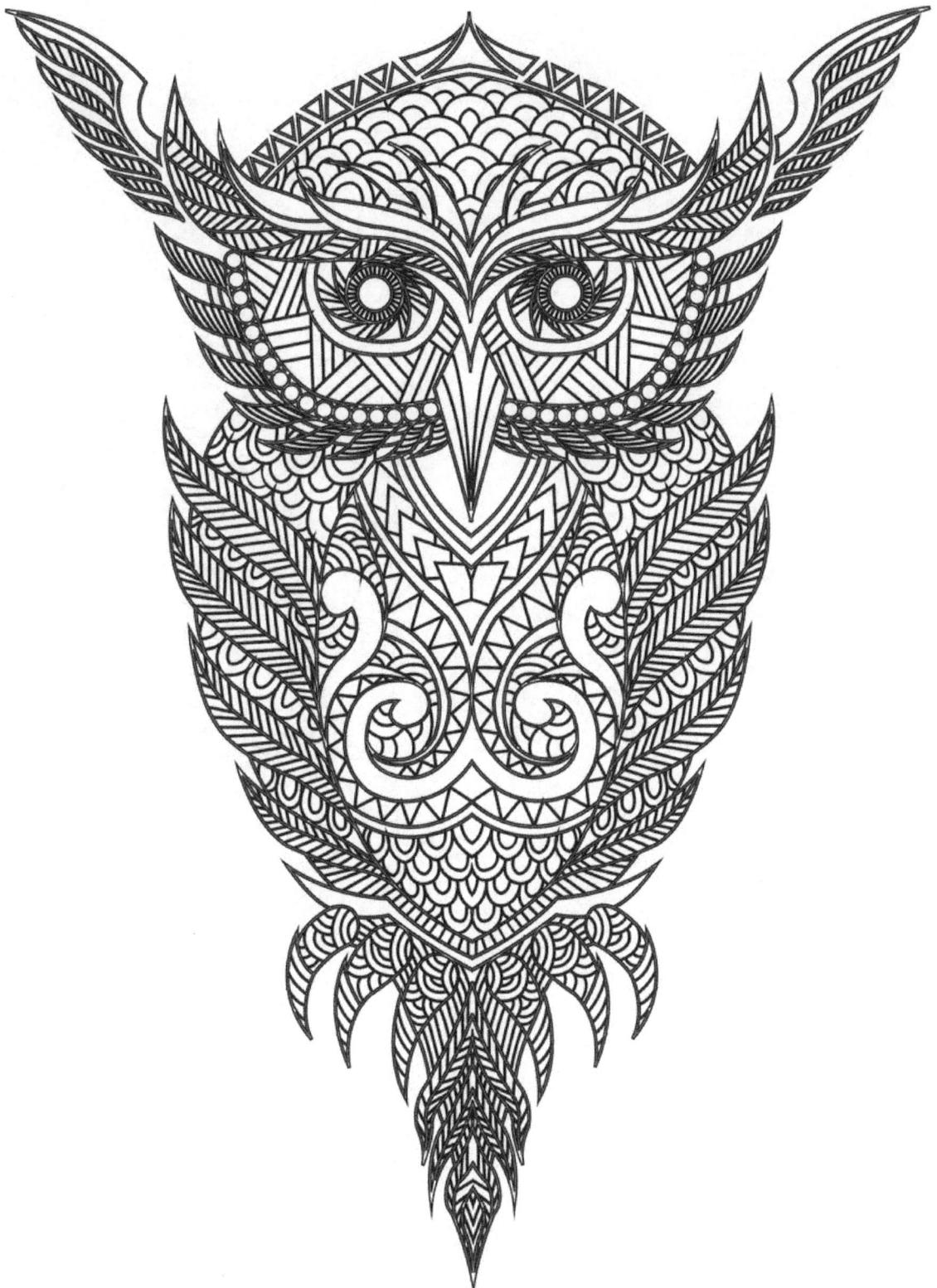

7

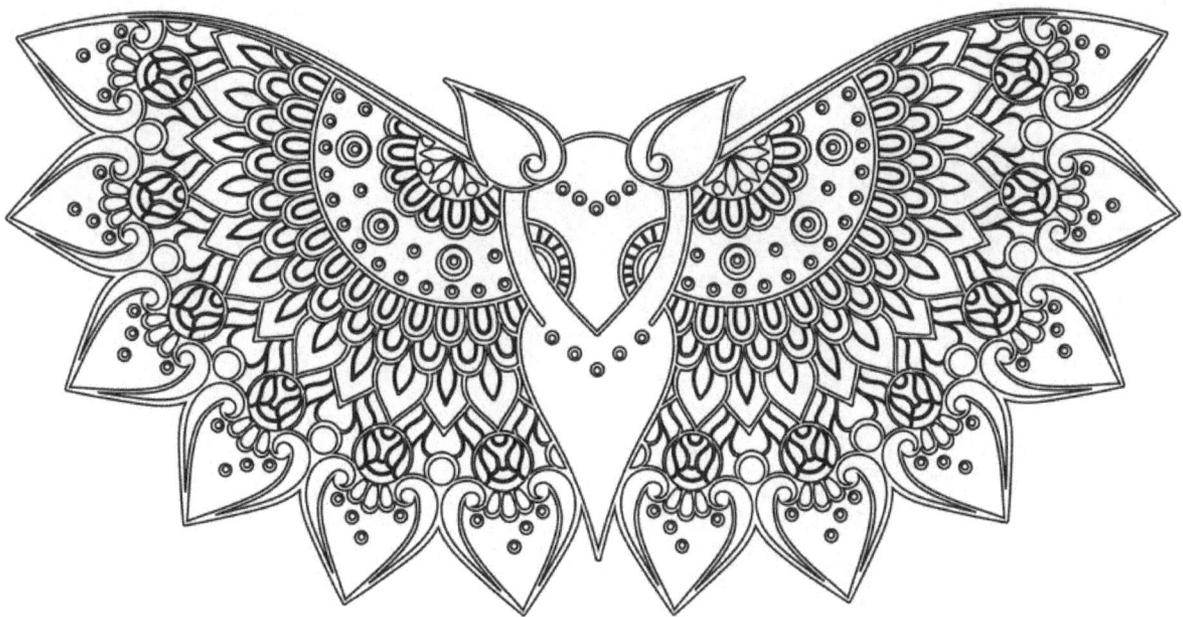

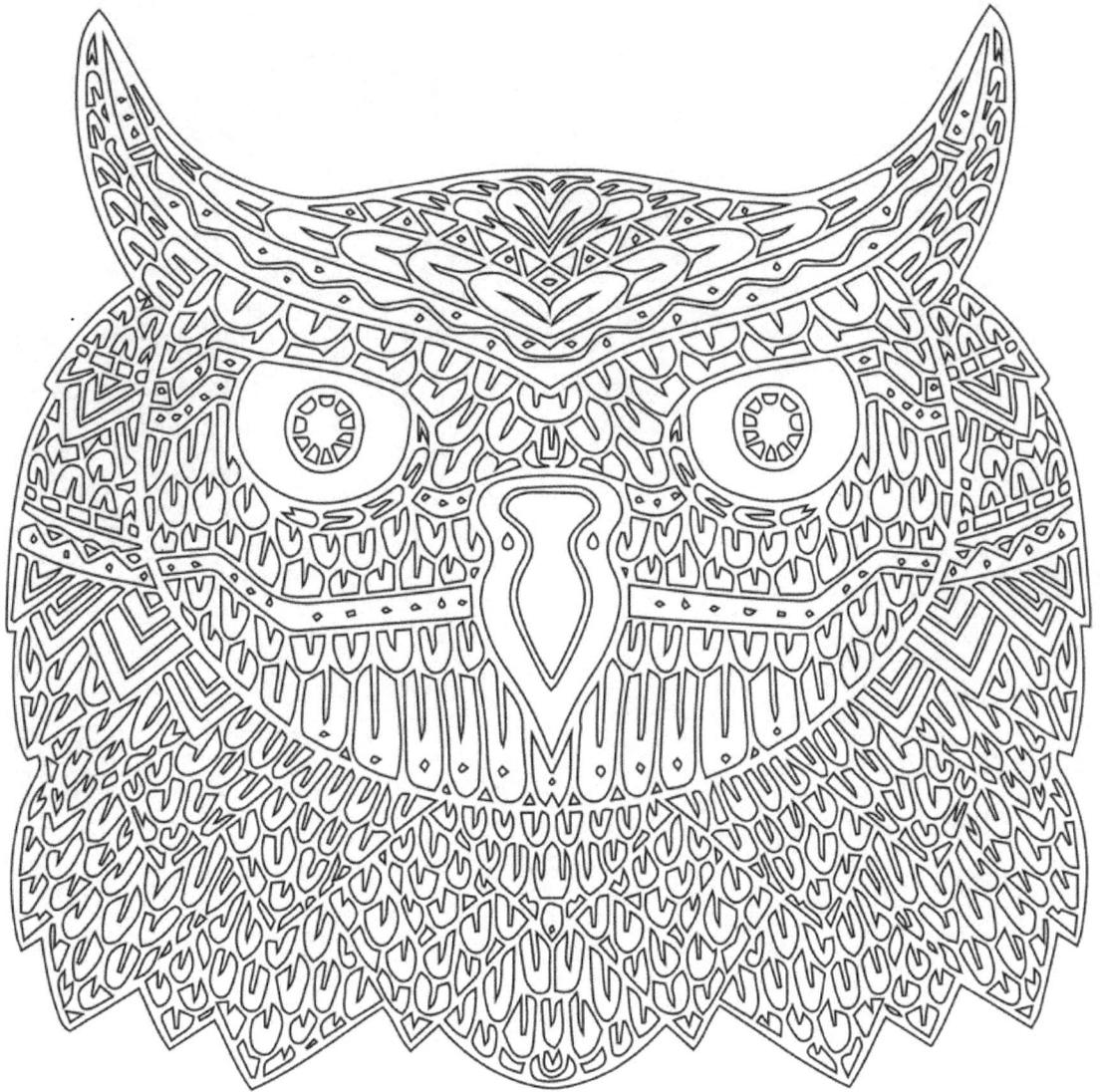

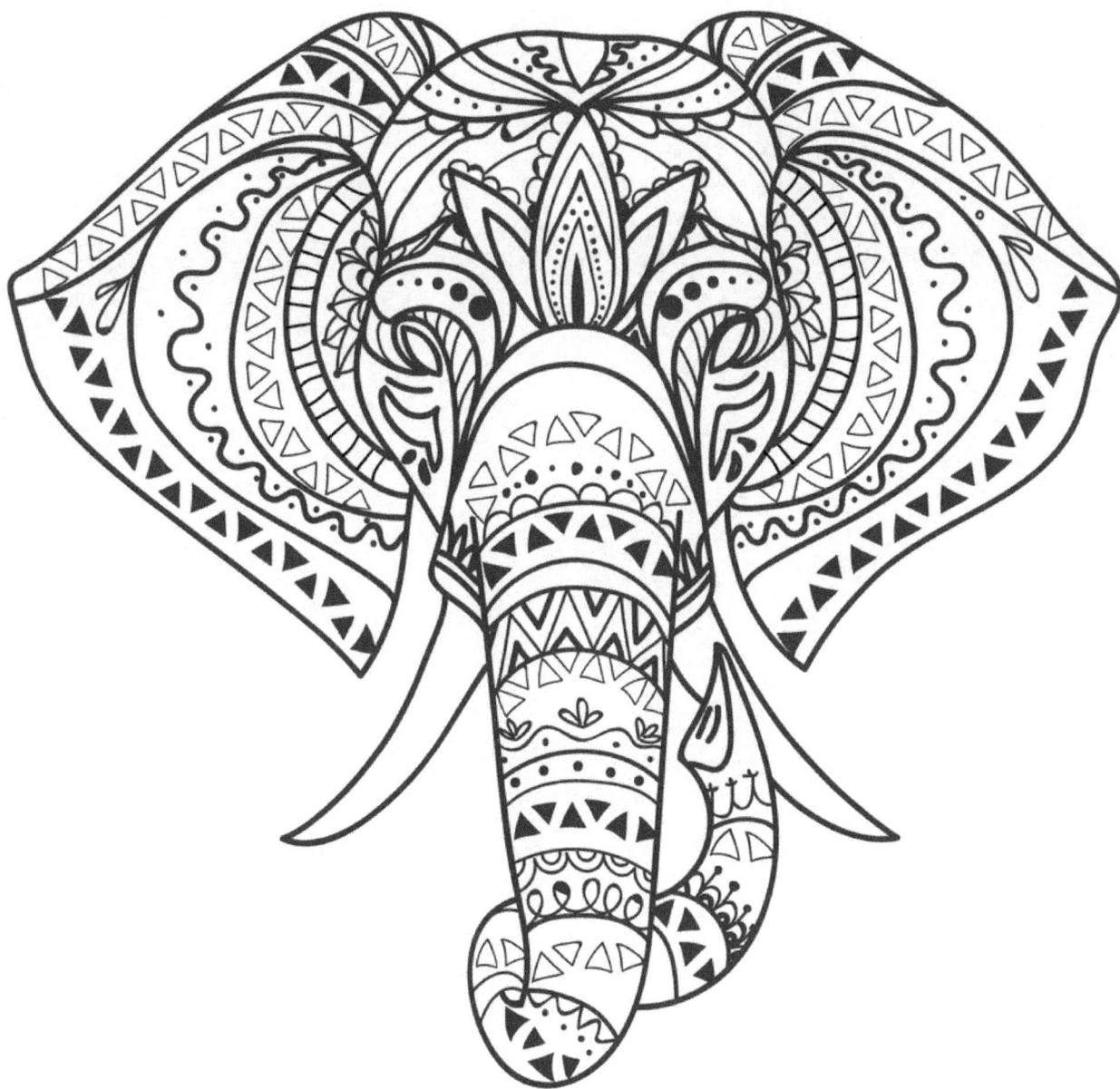

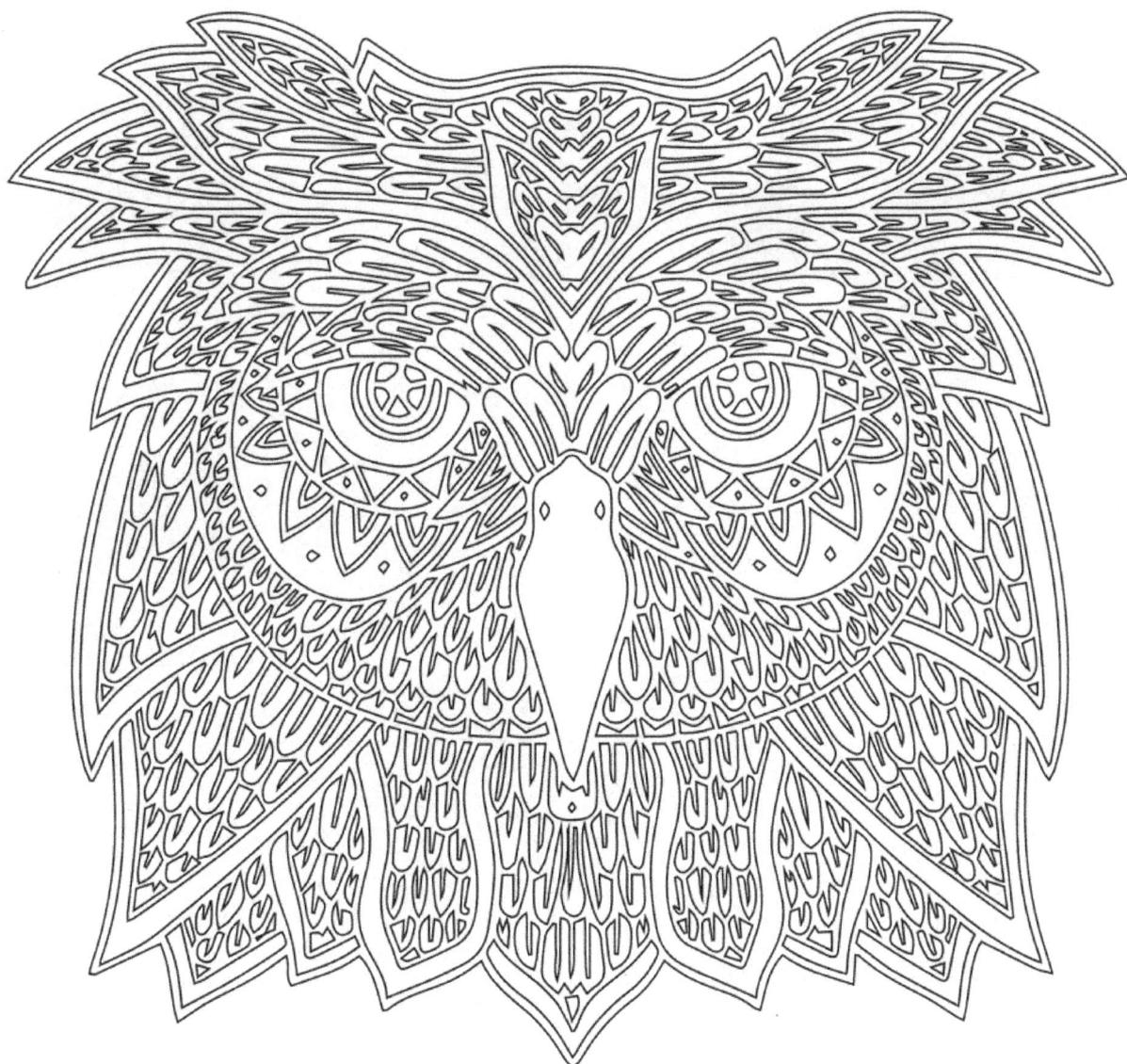

15

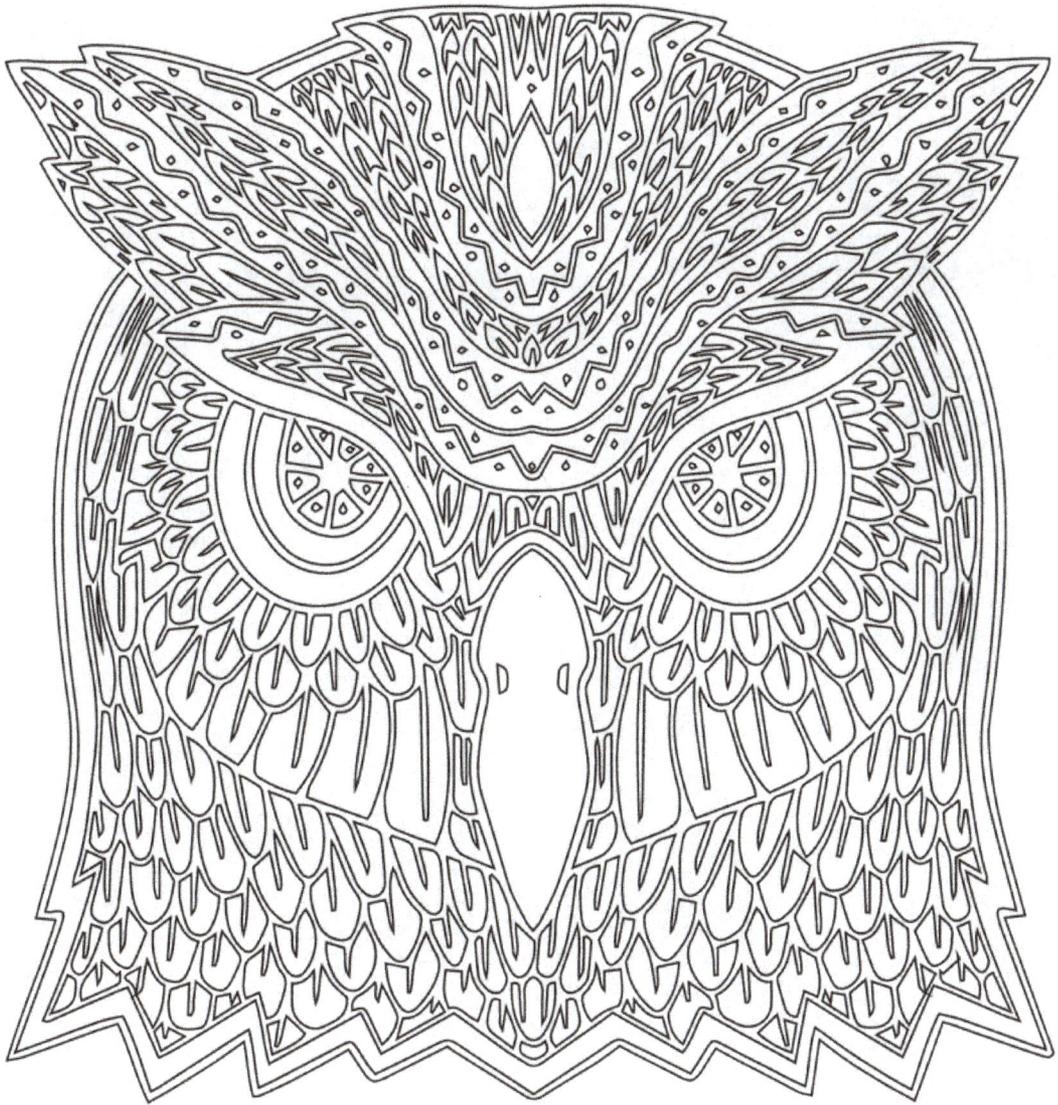

17

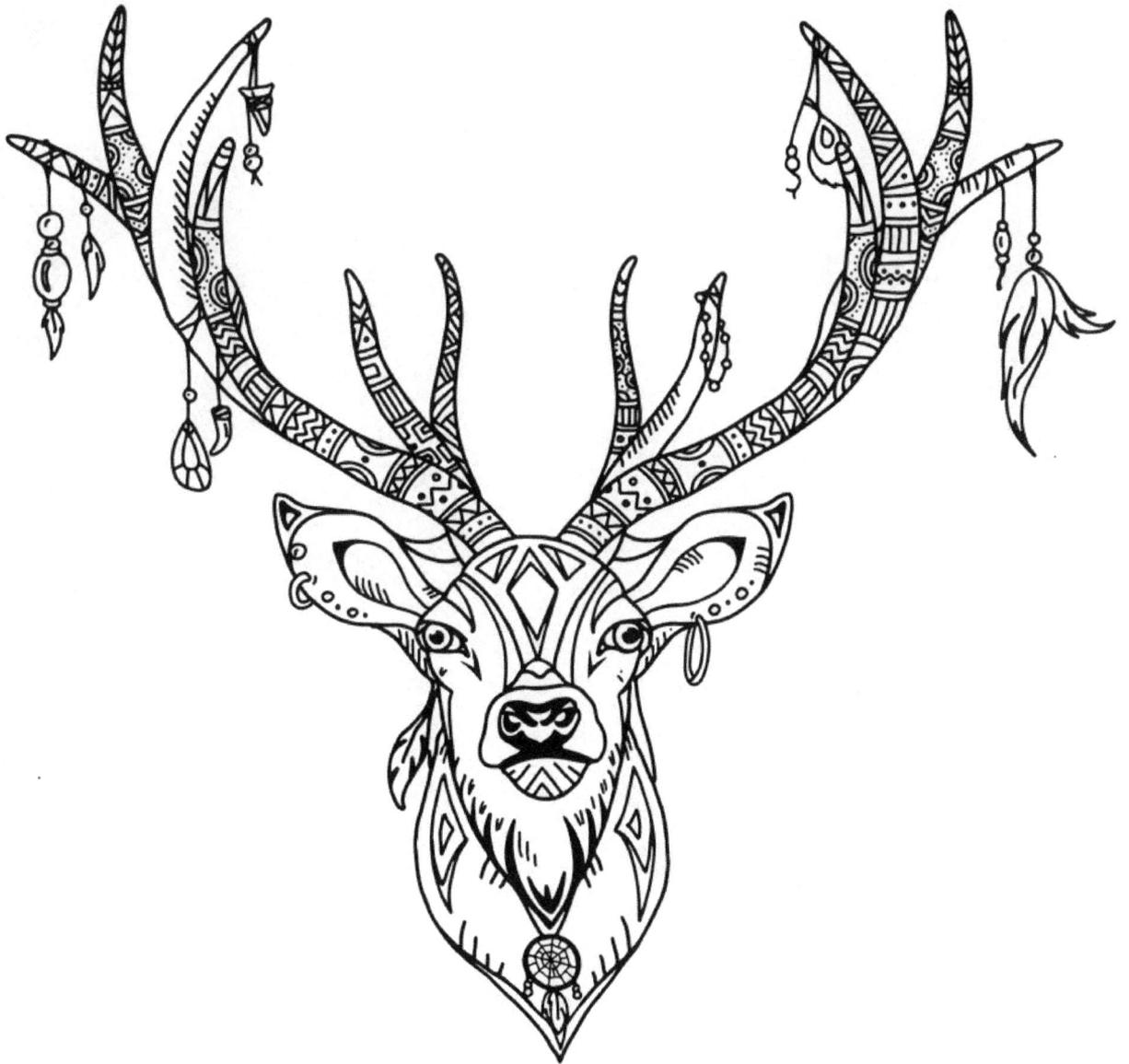

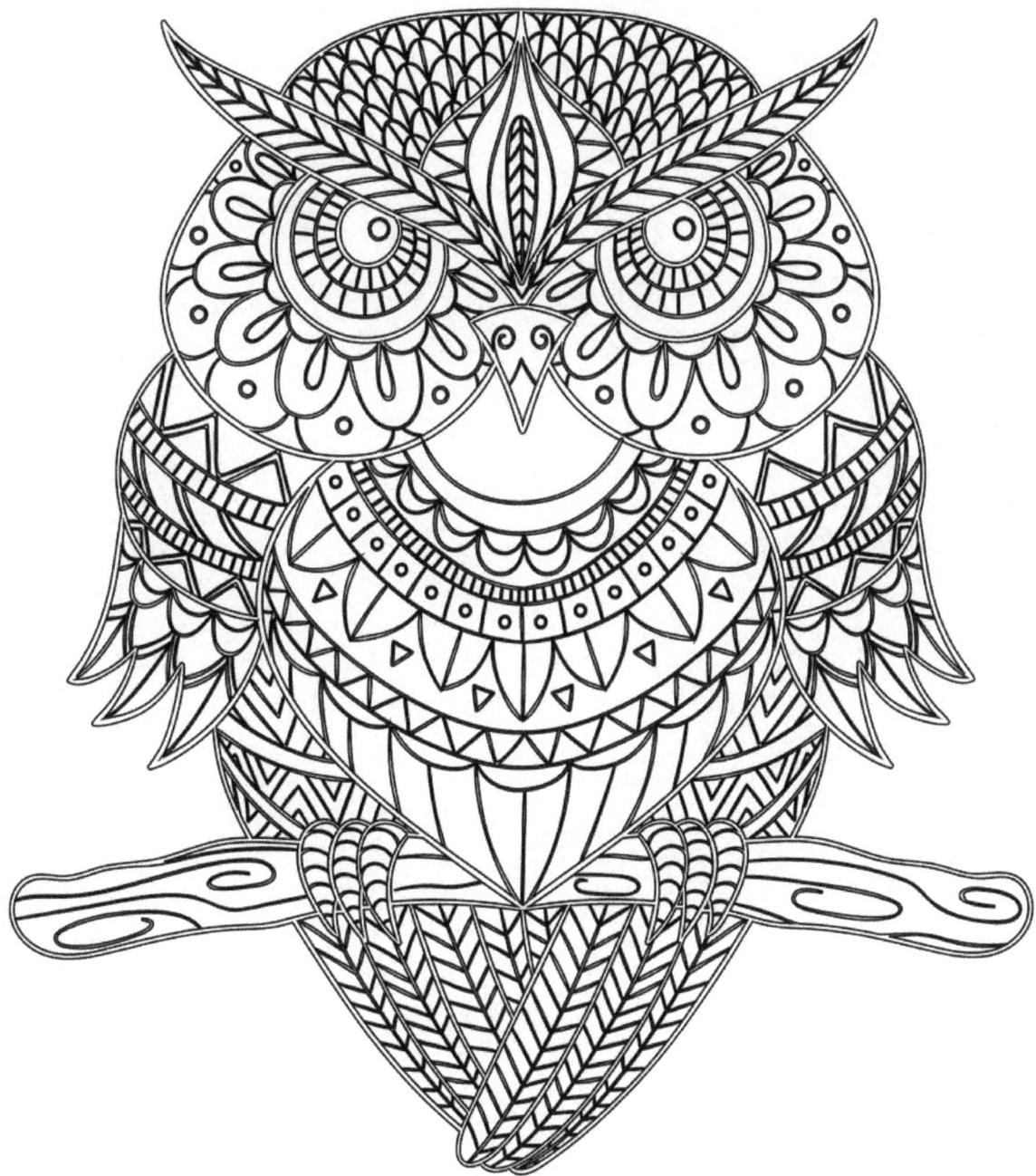

21

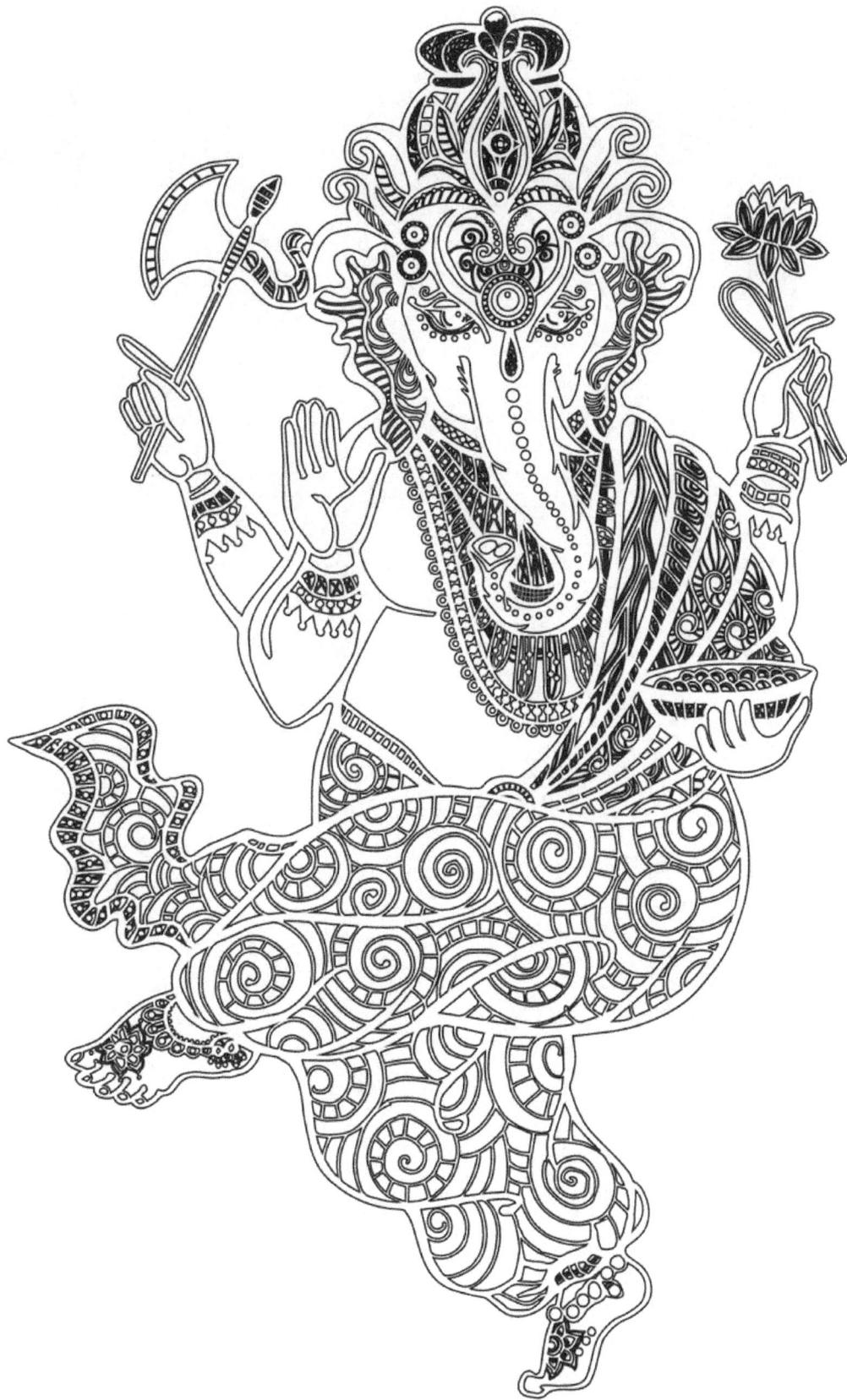

23

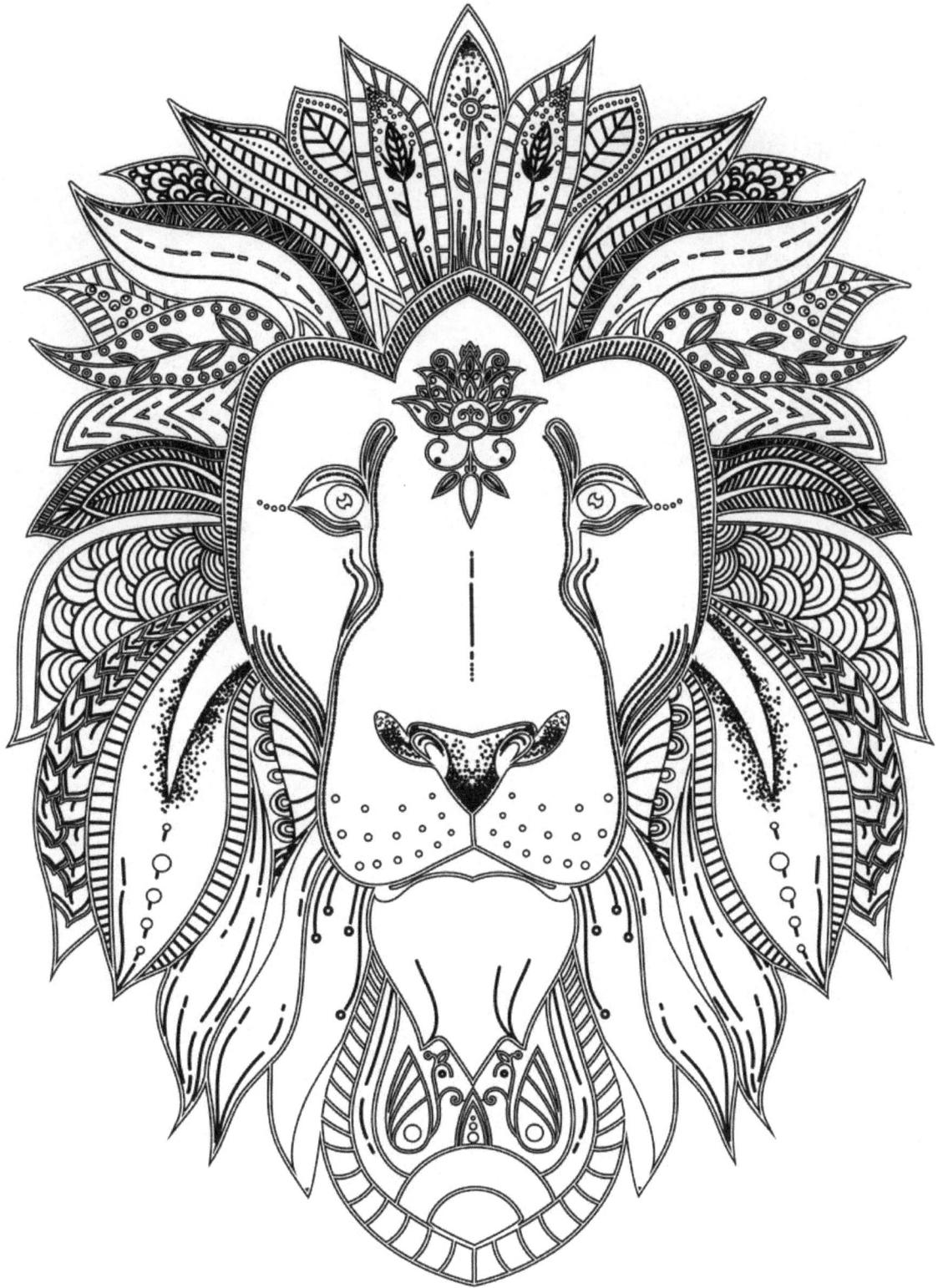

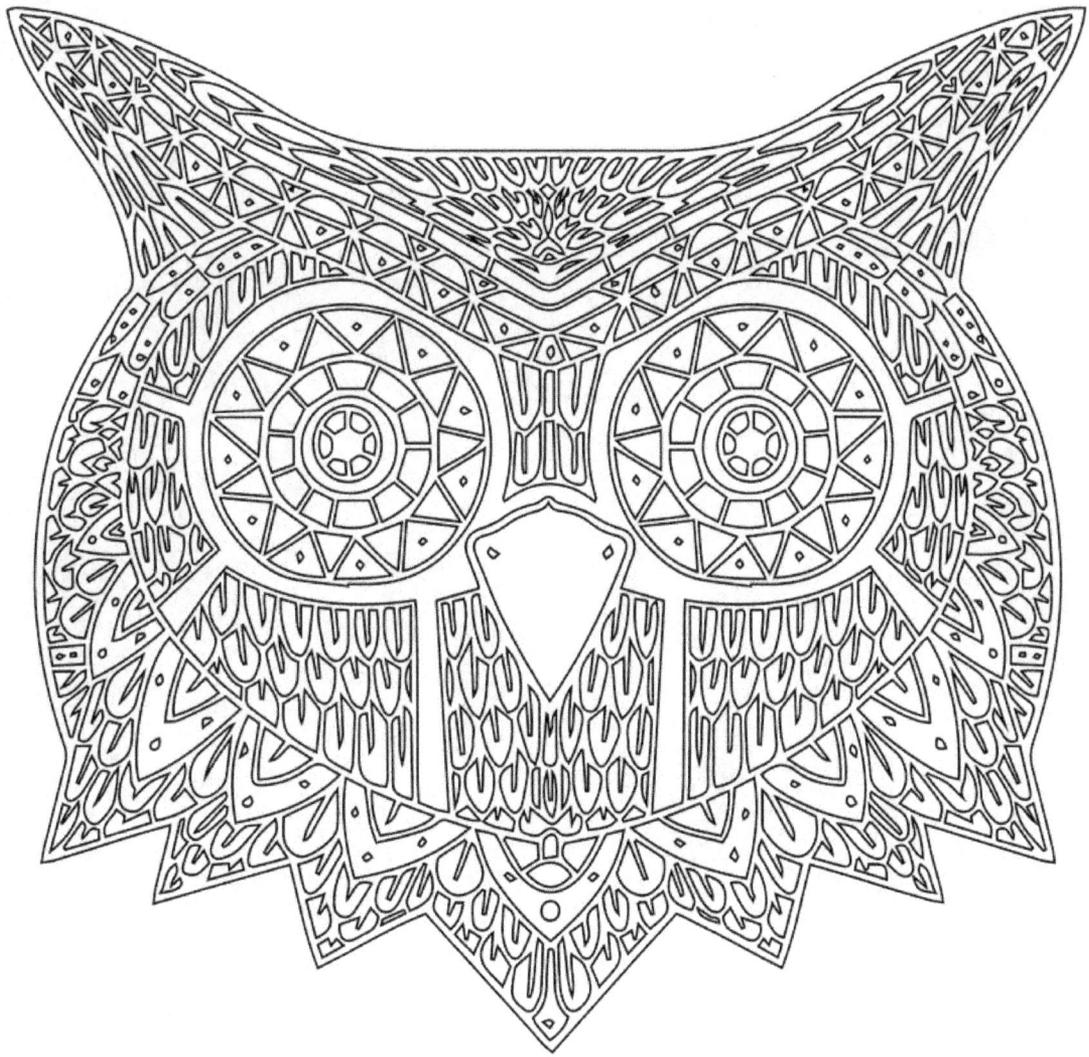

27

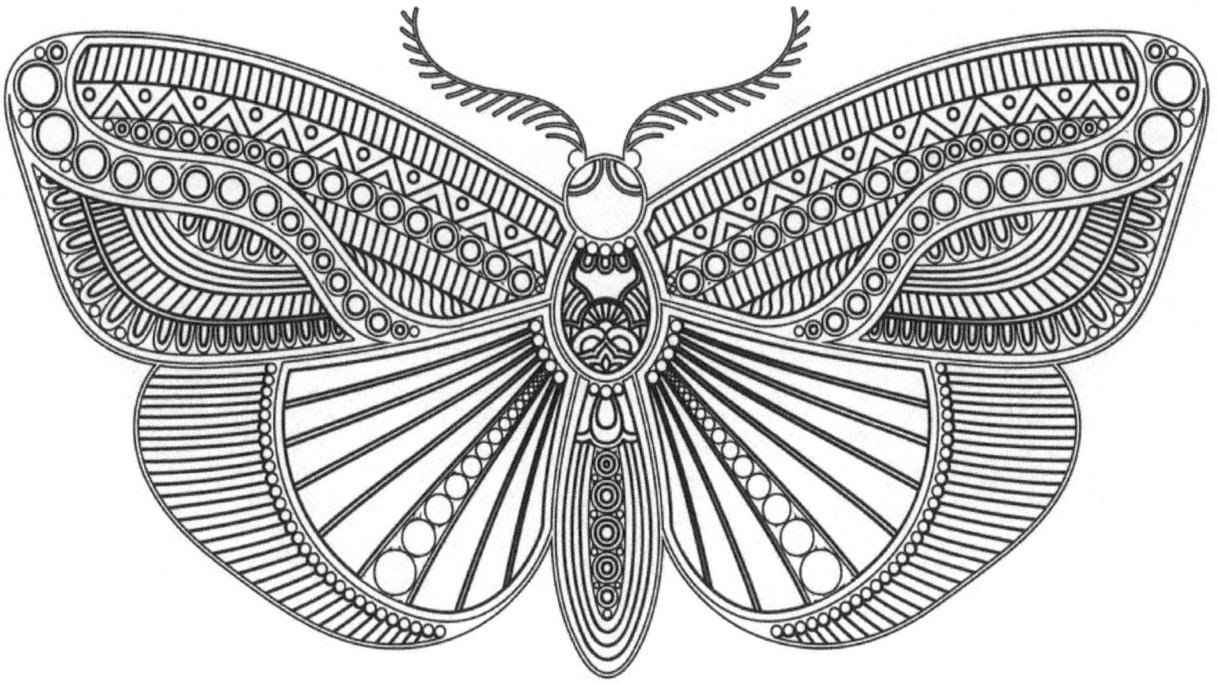

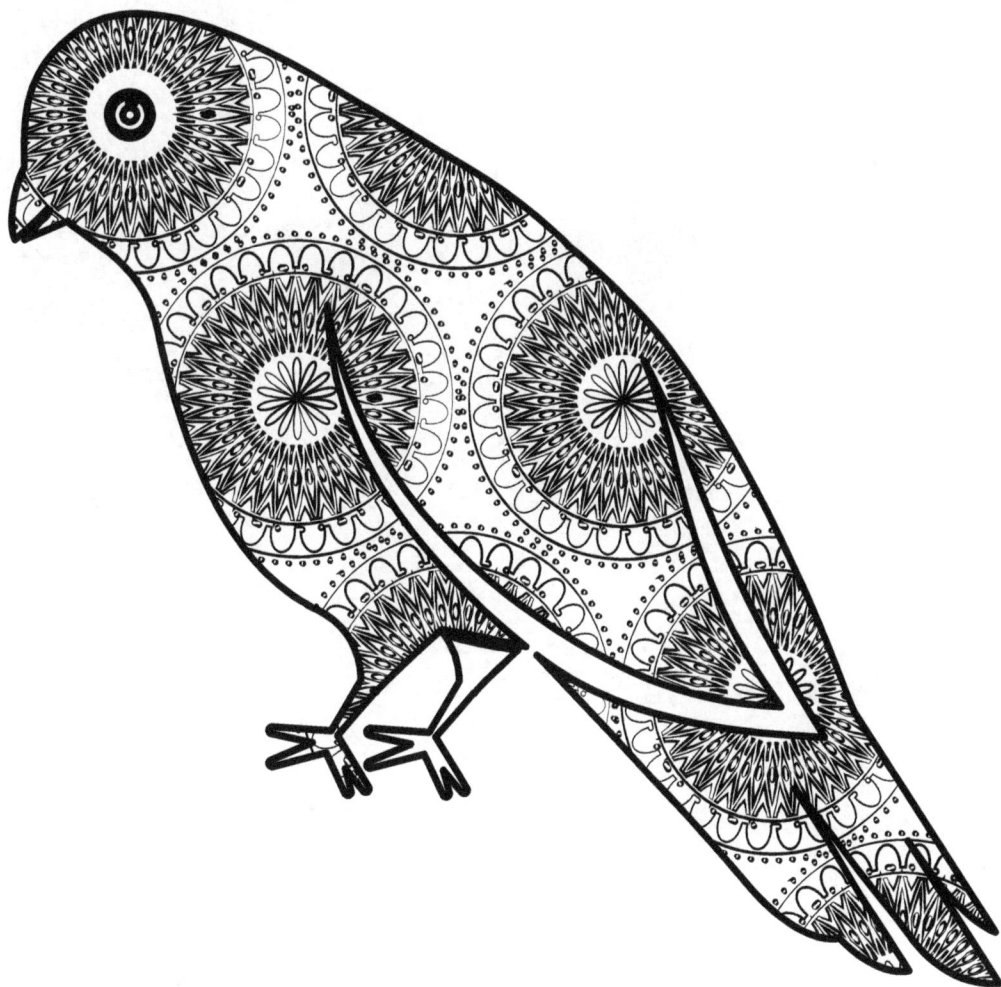

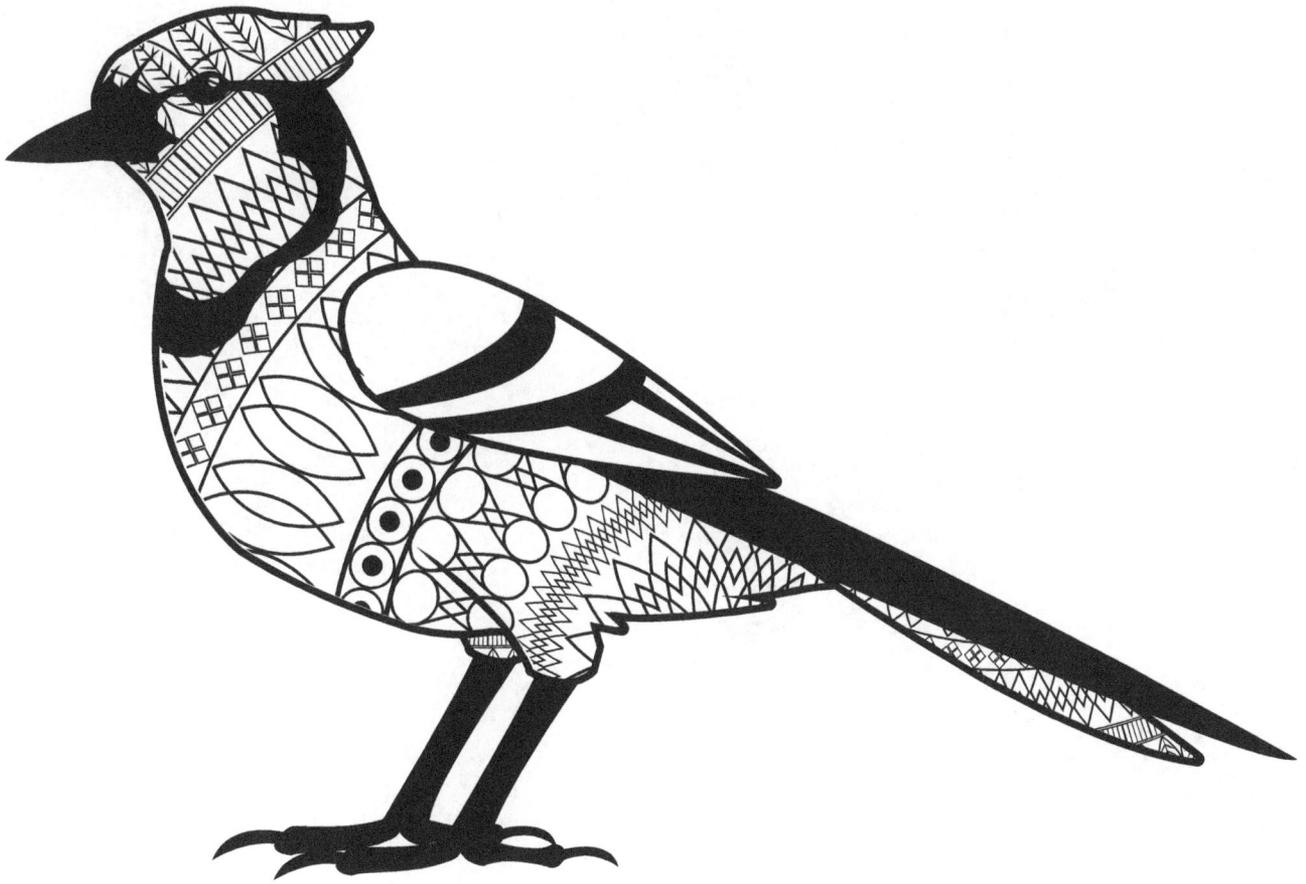

33

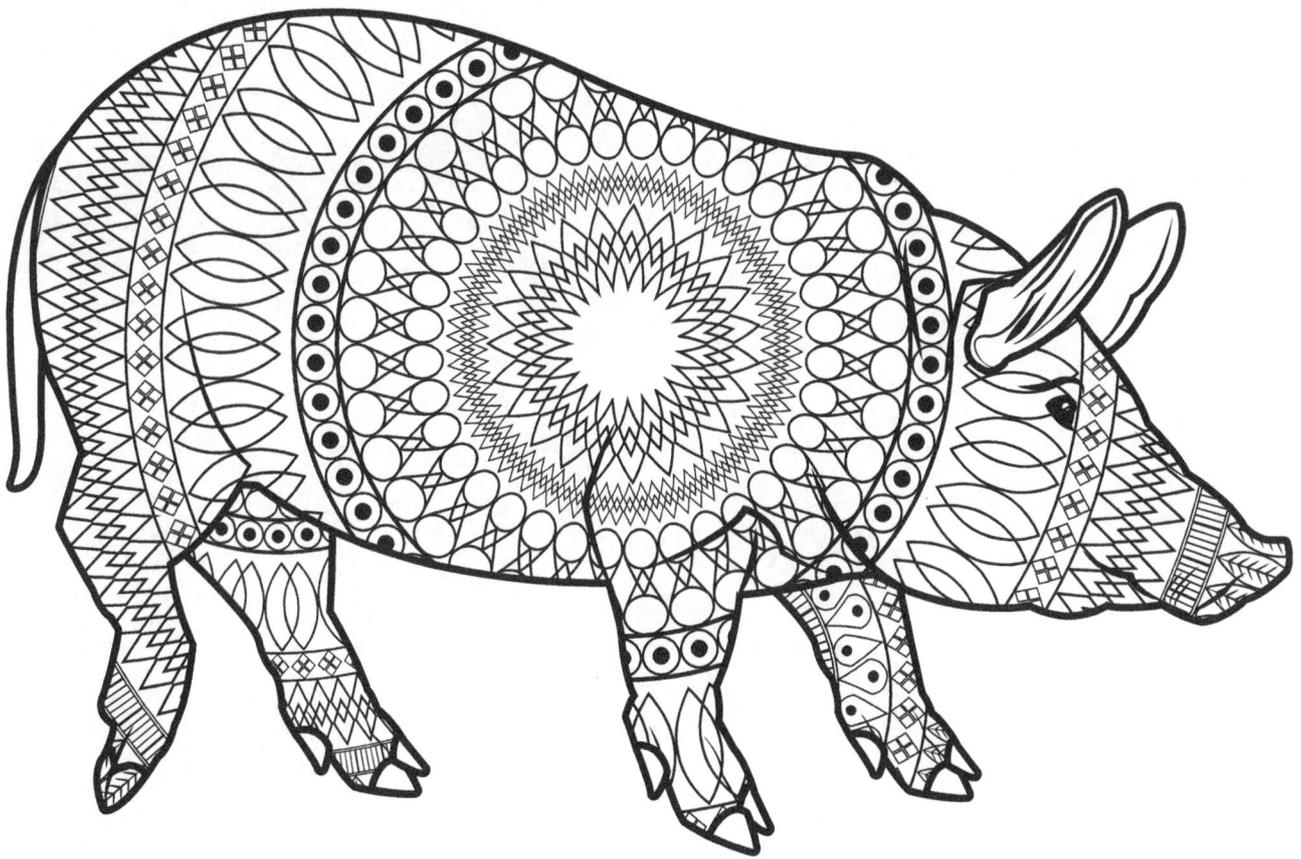

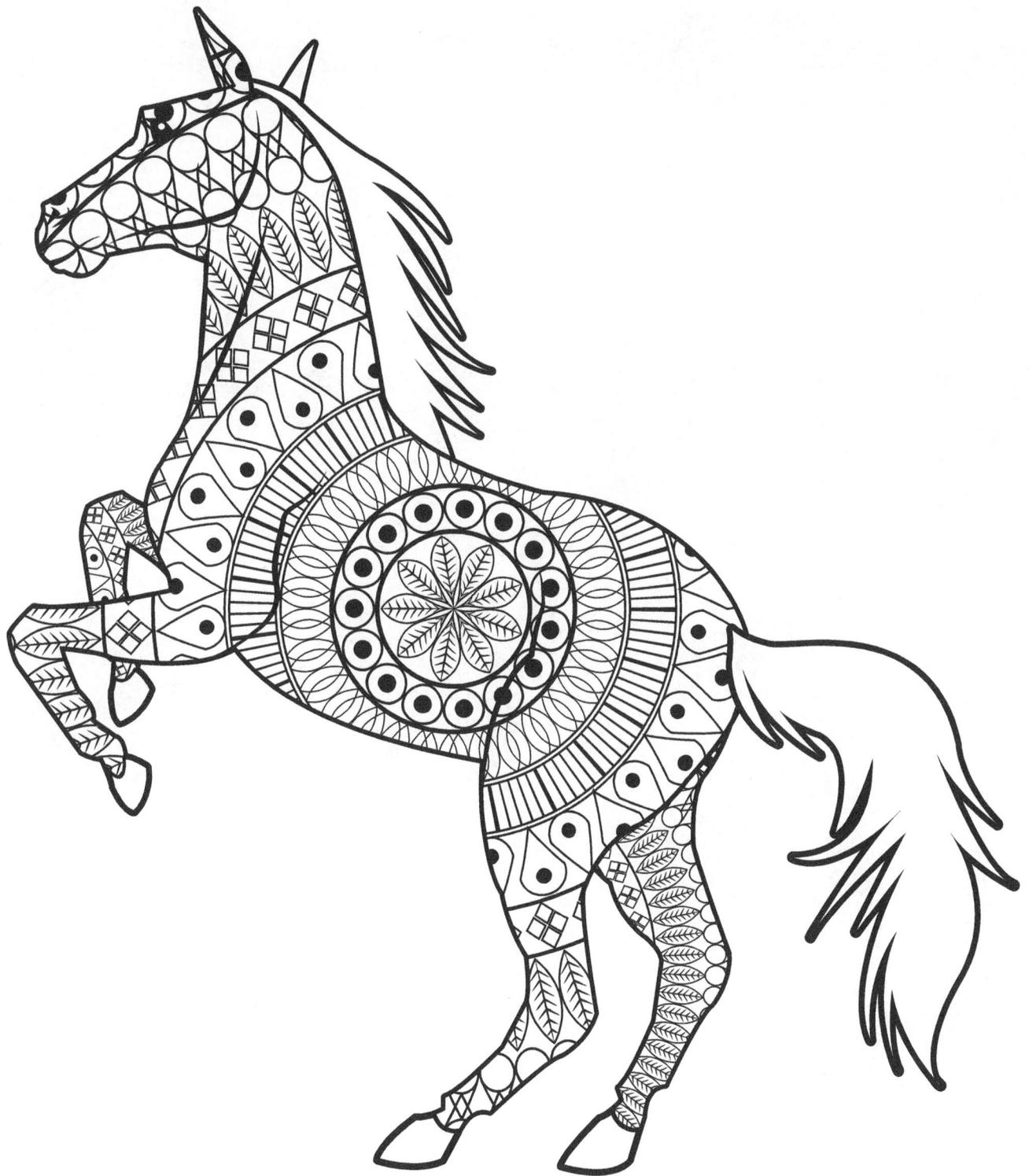

37

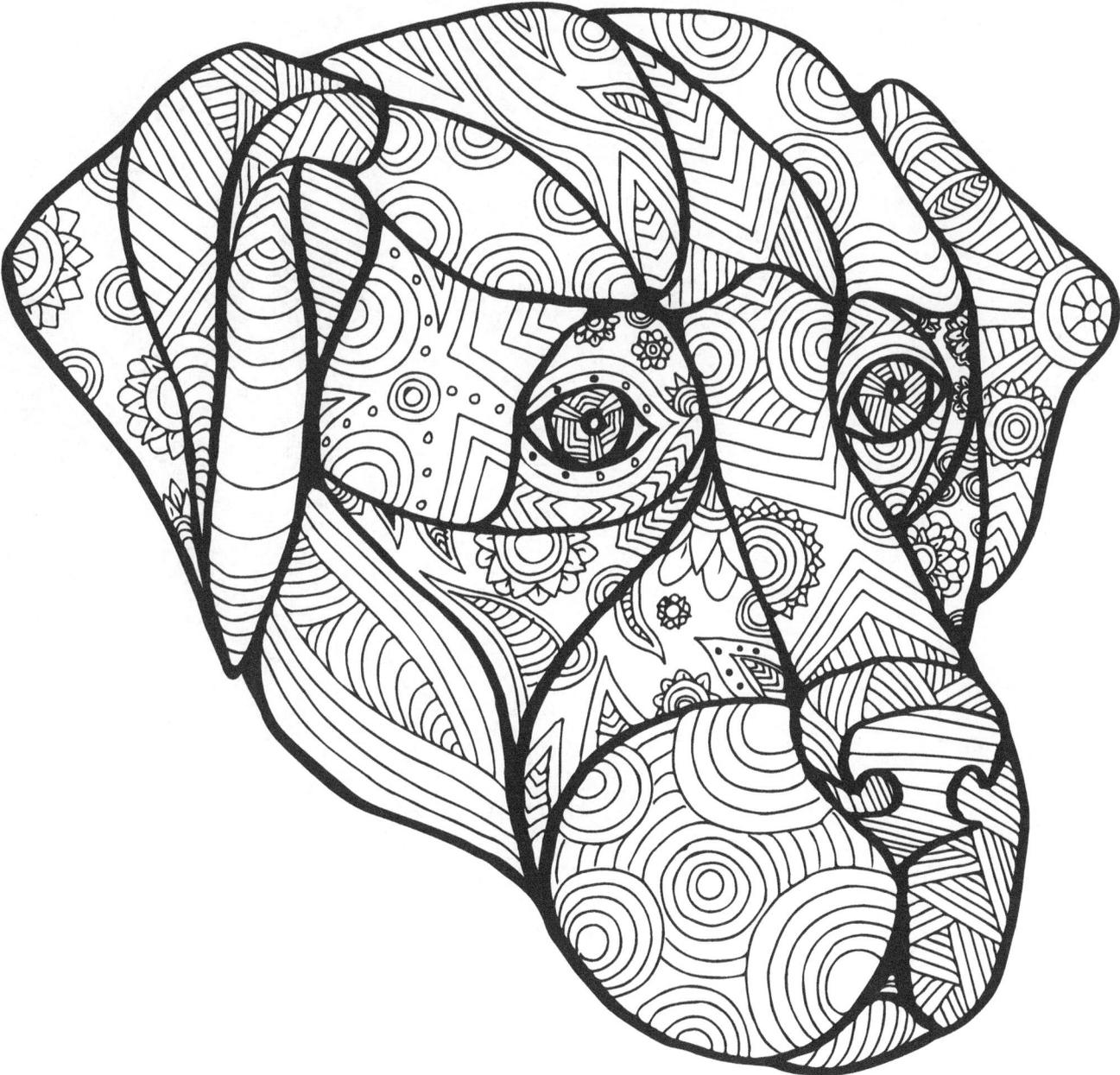

39

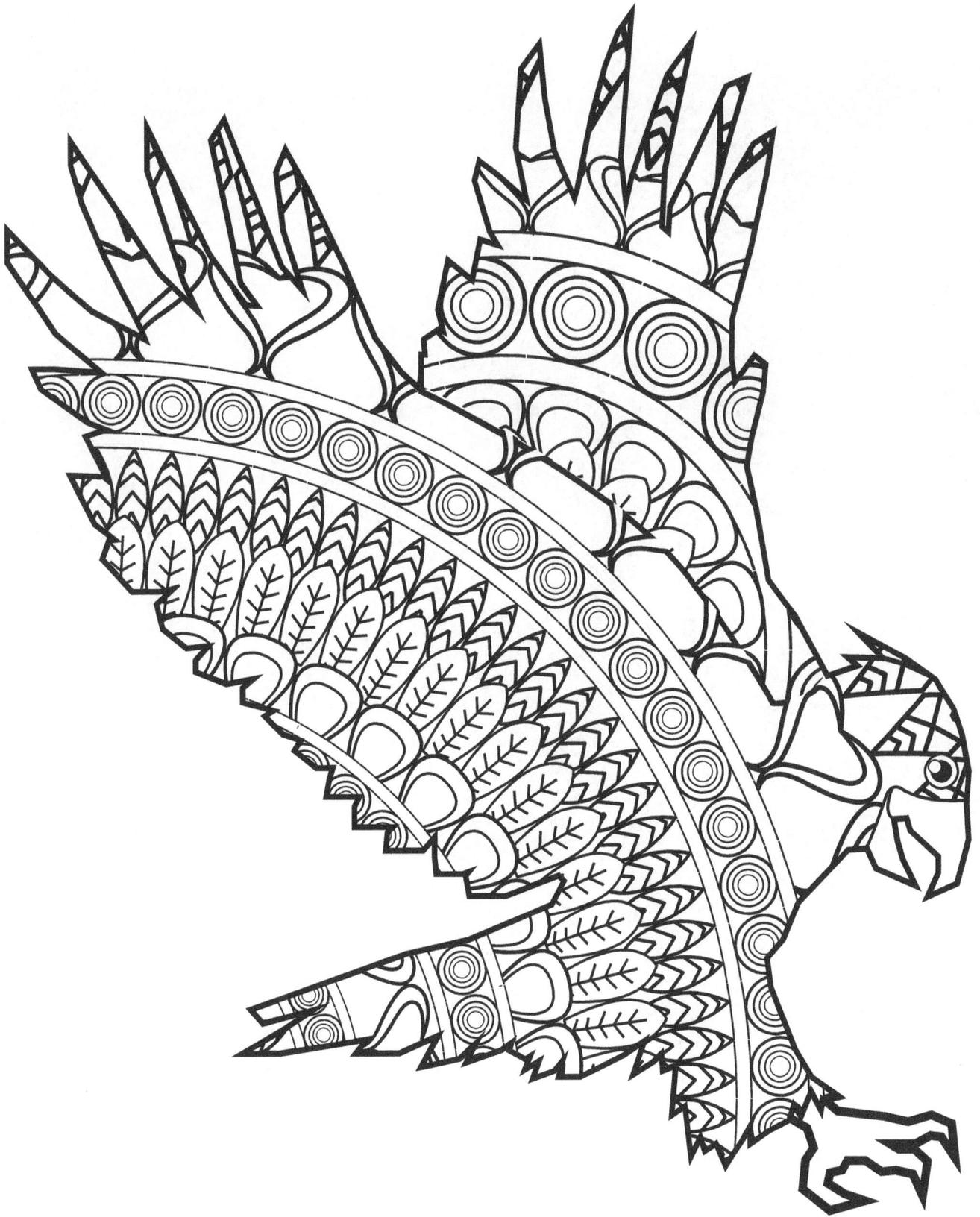

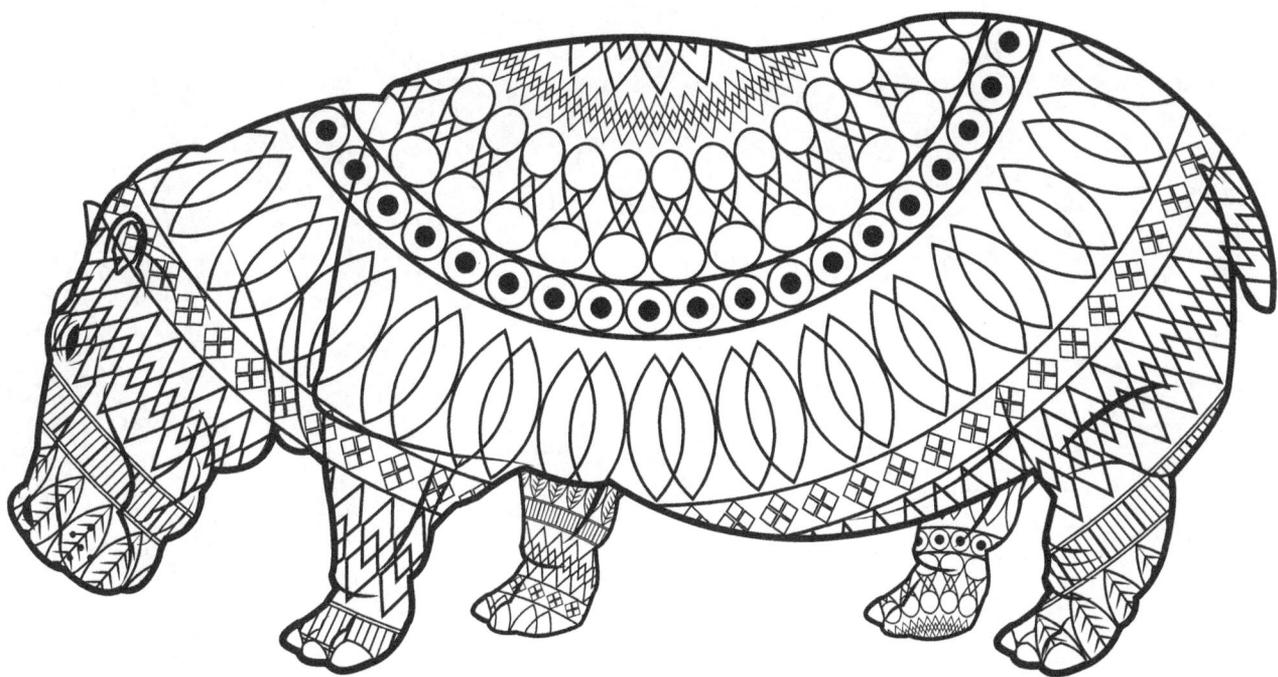

43

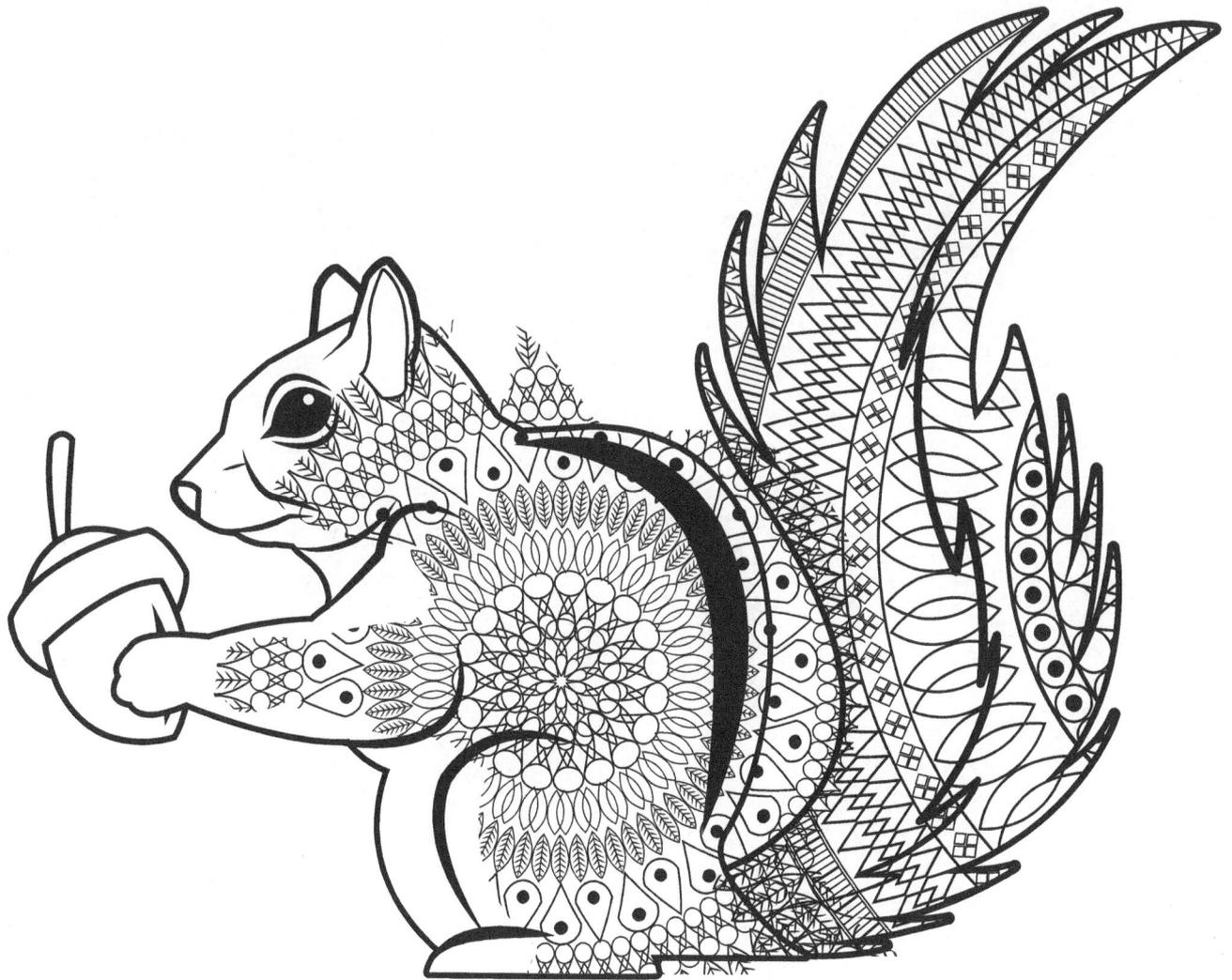

45

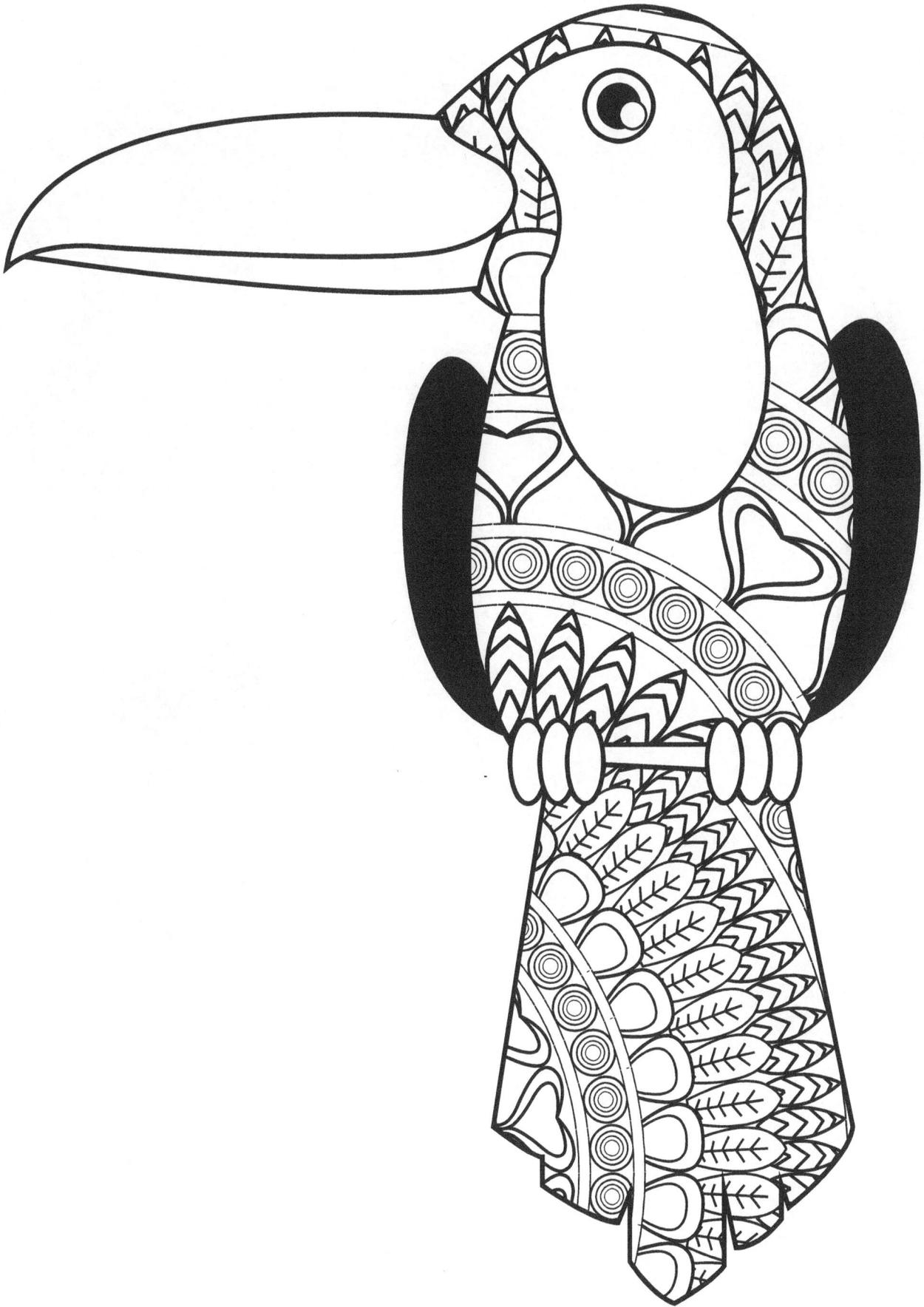

47

48

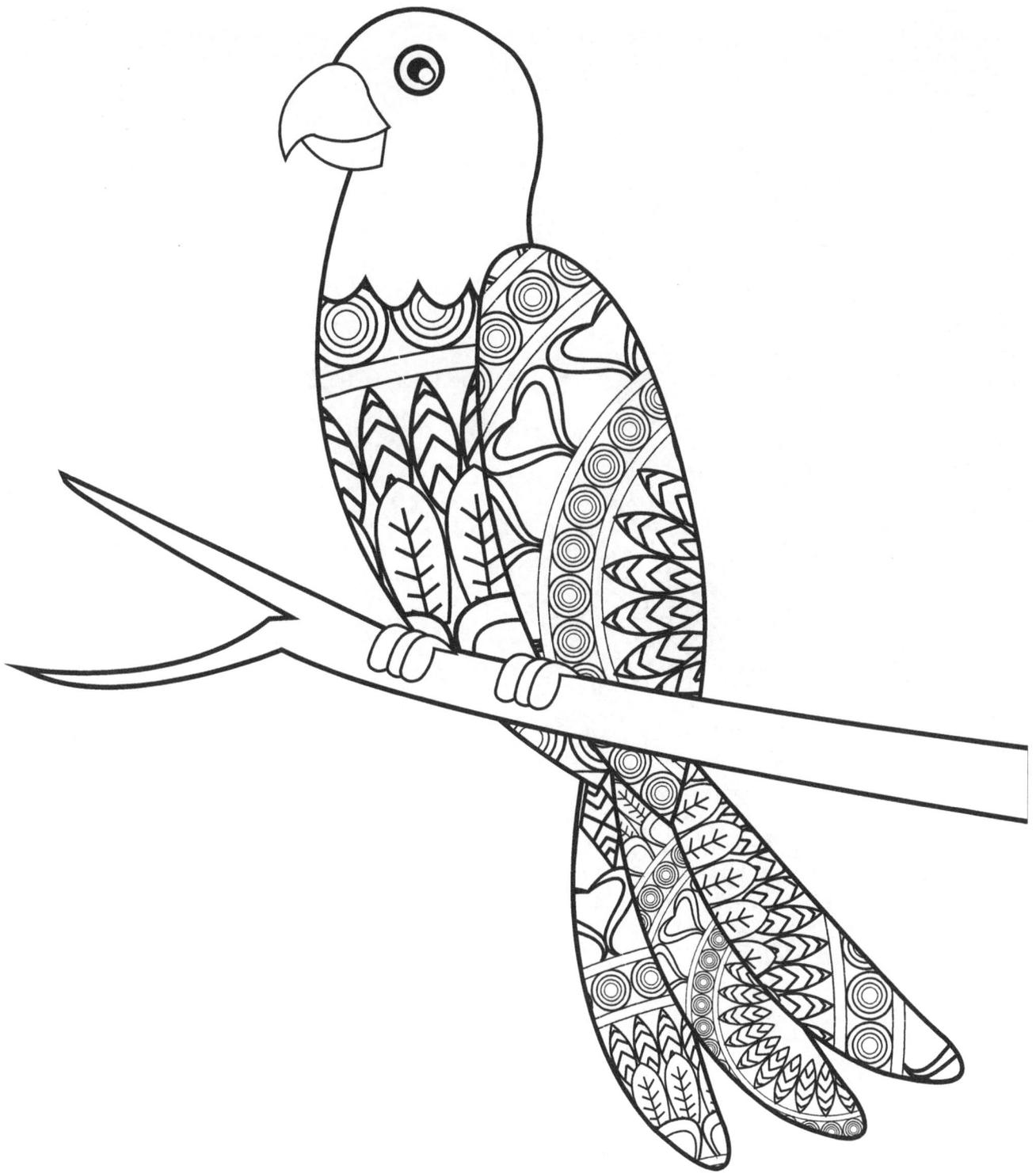

49

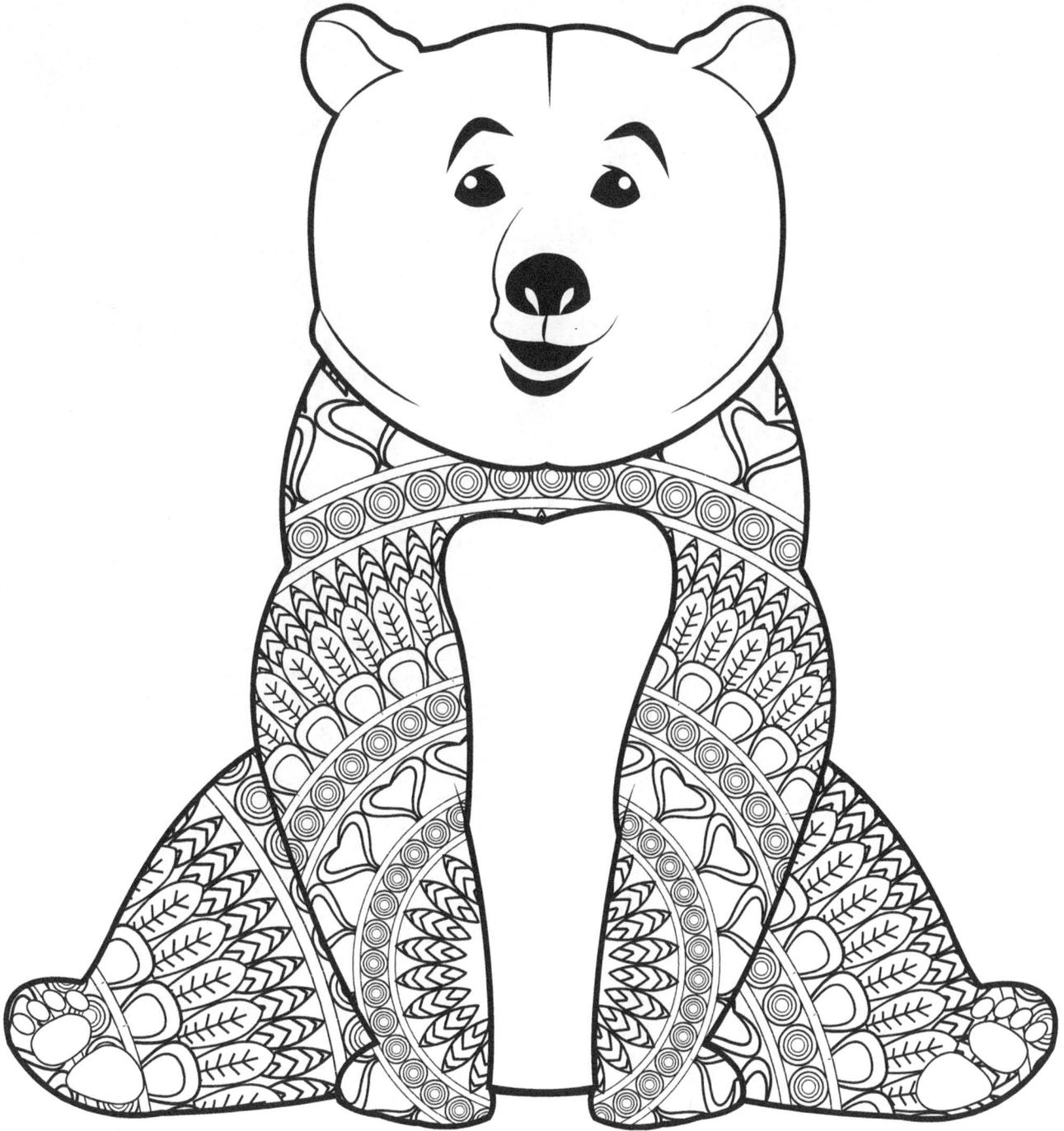

51

53

55

Coloring book for Adults

Thank you

We hope enjoyed our book
As a small family company
your feedback is very
important to us
Please let us know how you
like our book at:

RoverPhils34@gmail.com

CPSIA information can be obtained
at www.ICGtesting.com
Printed in the USA
BVHW060008250521
608000BV00010B/2262